Girls Who Comb the Shore

POEM BY
SILKE STEIN

ART BY
CHRISTINA GRAY

BEACH URCHIN
BOOKS

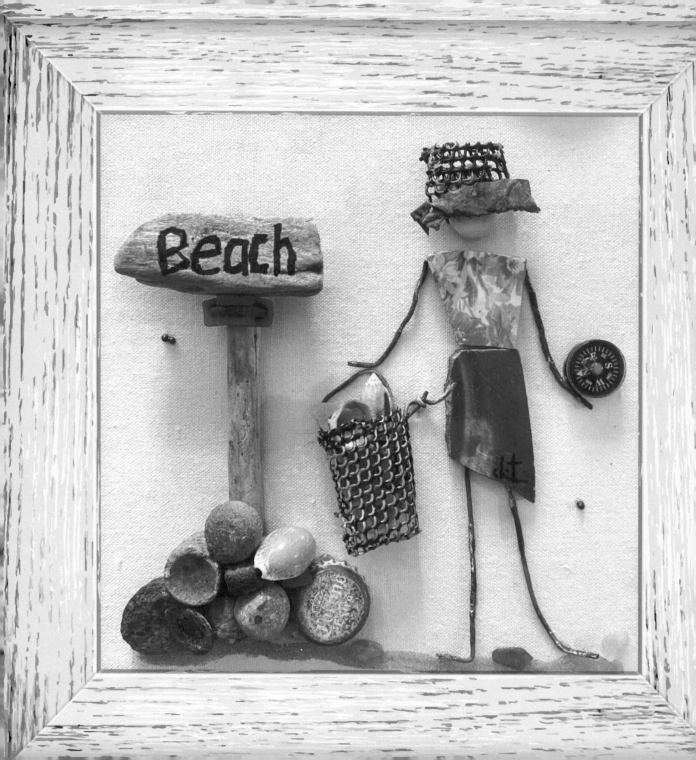

I am a girl

who combs the shore;

it is the place

that I adore,

where I will go

whenever I

do crave to watch

a seagull fly,

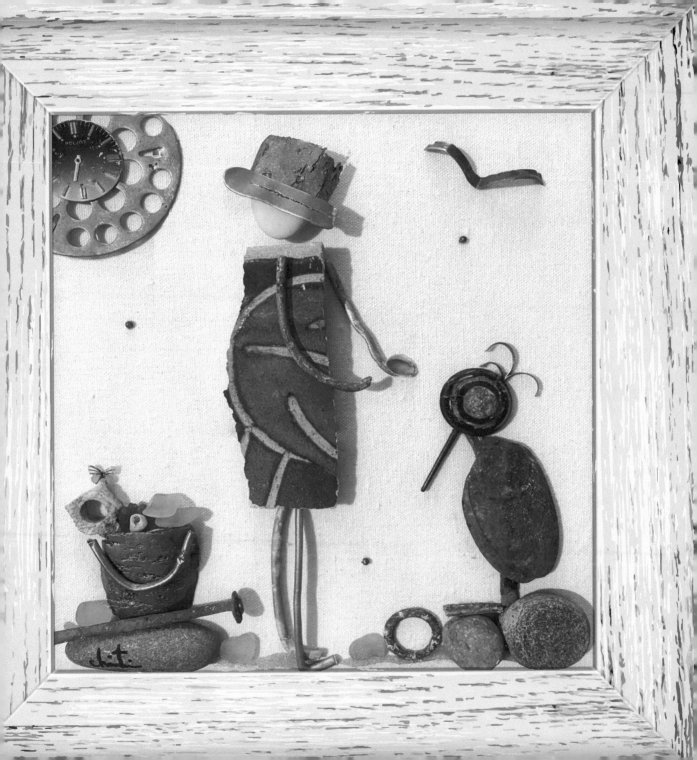

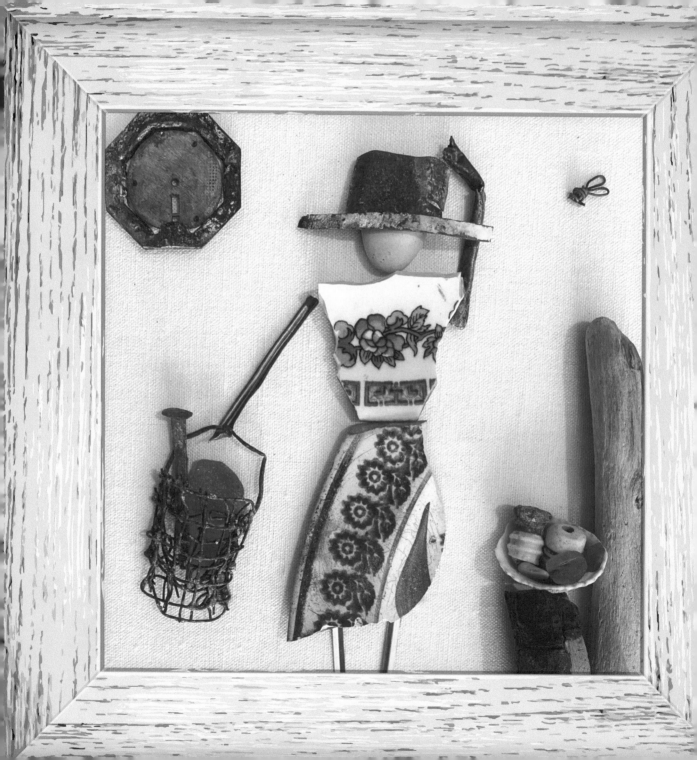

and long

for salty spray and light,

fresh gales that make

my thoughts take flight,

and endless walks

with ocean views

that feature all

those lovely blues.

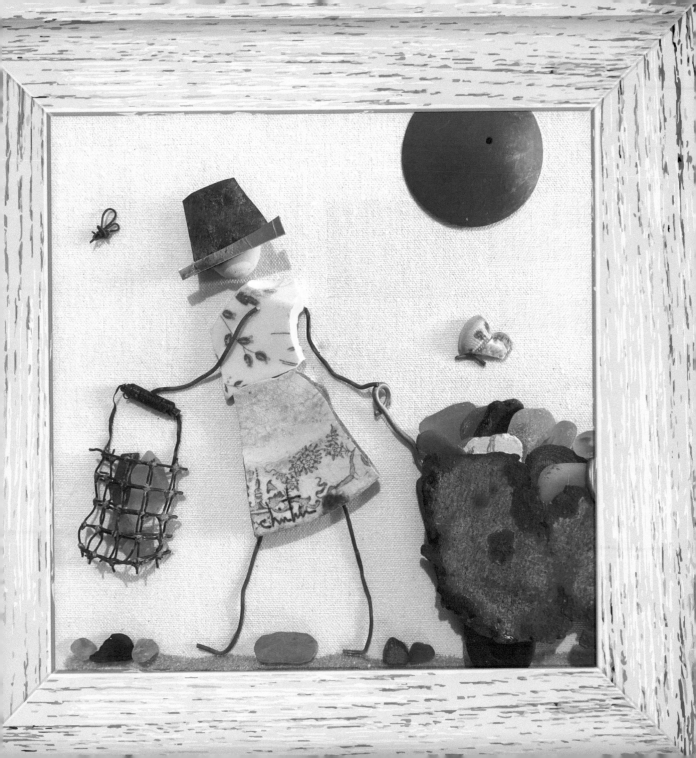

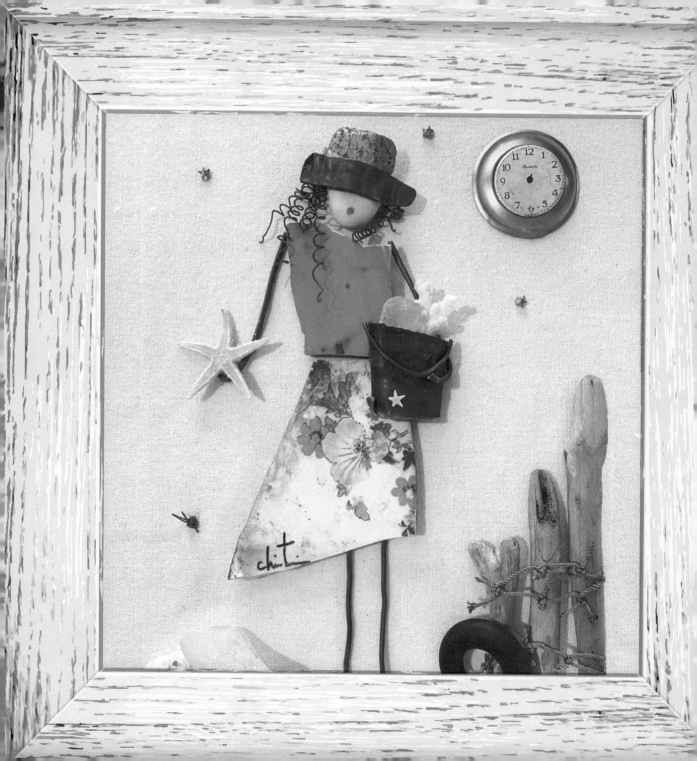

Here, any tide

may kindly bring

in a surprising

sea-born thing.

The surf prepares

small gifts for me:

smoothed shards

of glass and pottery.

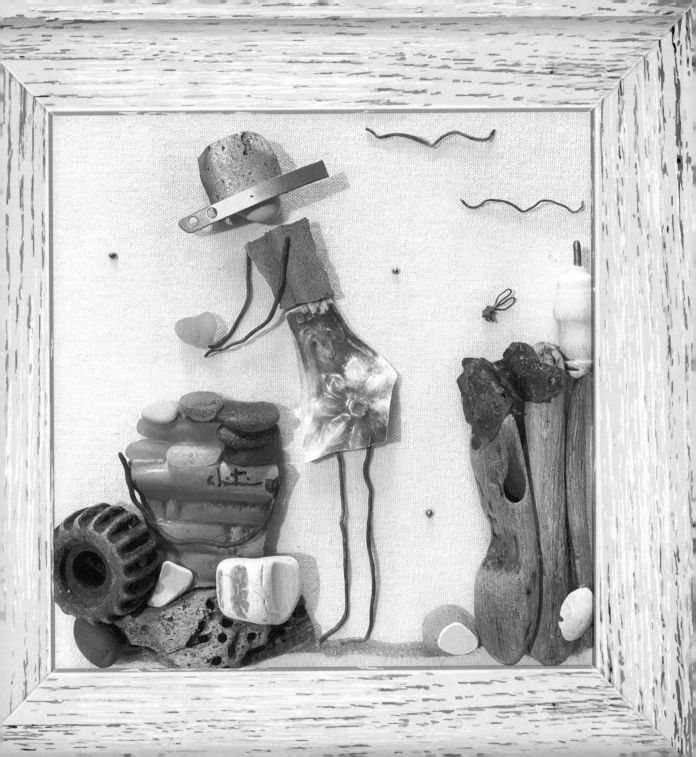

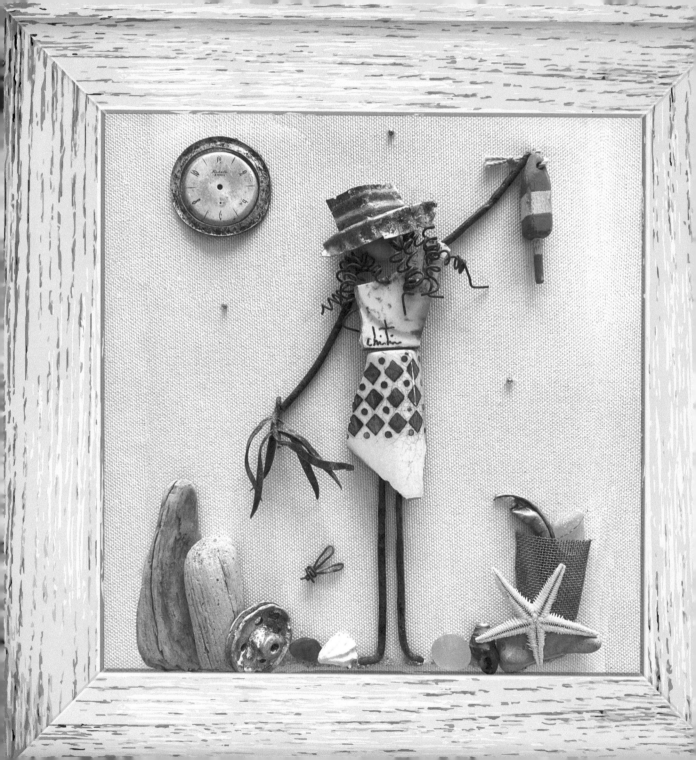

So much gets washed up

at the coast —

I don't know what

I love the most:

Maybe a turquoise fishing float?
A vintage bottle with a note?

A stunning little china shard
that's painted like a work of art?

Some marbles with a swirl of white?
Glass that glows green under black light?

A shell-encrusted lobster cage?
A marine fossil of great age?

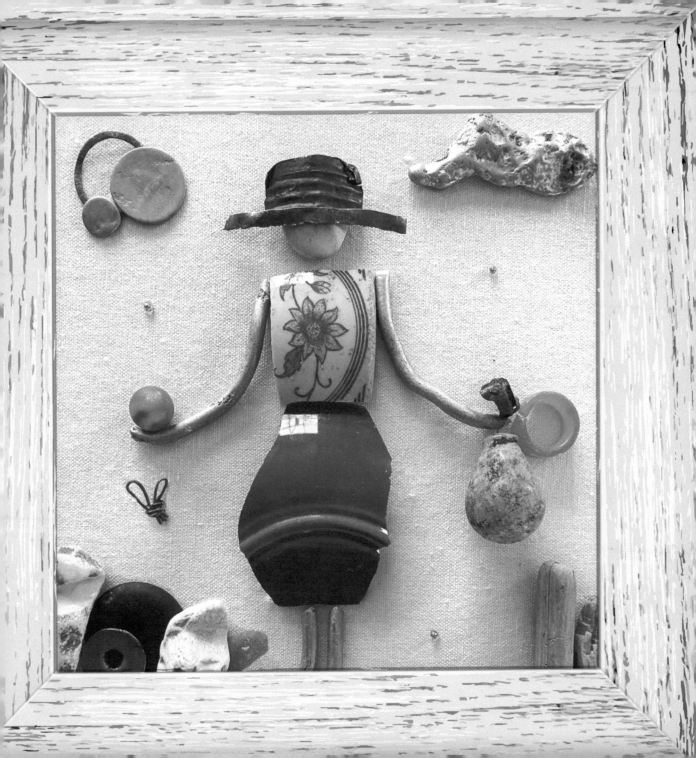

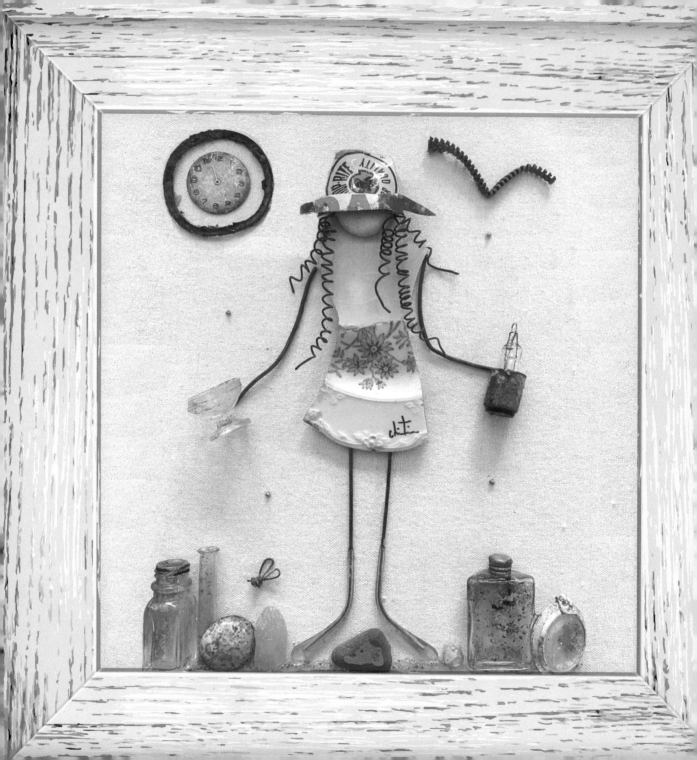

A Frozen Charlotte's tiny head?
Or her porcelain feet instead?

A perfume vial from olden days?
Parts of an amberina vase?

Clear glass the sun has turned light pink?
An antique well that once held ink?

An abalone's shimm'ring shell?
A stopper that is tumbled well?

Some cockles, mussels, scallops, or
the crystal knob of an old door?

A little makeshift driftwood boat
that children's hands have set afloat?

The fancy pin a southern belle
wore years ago on her lapel?

A brass weight, and a silver spoon,
or a genuine gold doubloon?

The sharp tooth of a shark or whale?
A smallish jug once used for ale?

A seafoam-colored Coke kick-up?
The handle of a coffee cup?

Perhaps a pearl, precious and rare?
A piece of blue-glazed earthenware?

A late-Victorian lampshade bead?
Bunches of flowerlike rockweed?

Smooth rocks and pebbles of all sorts:
Agates and amber, jasper, quartz?

A clay pipe that a sailor smoked?
A sun hat that the sea has soaked?

The awesome piece that truly seems
beyond your wildest sea glass dreams?

An oblong, multi-colored buoy?
A funny, old, forgotten toy?

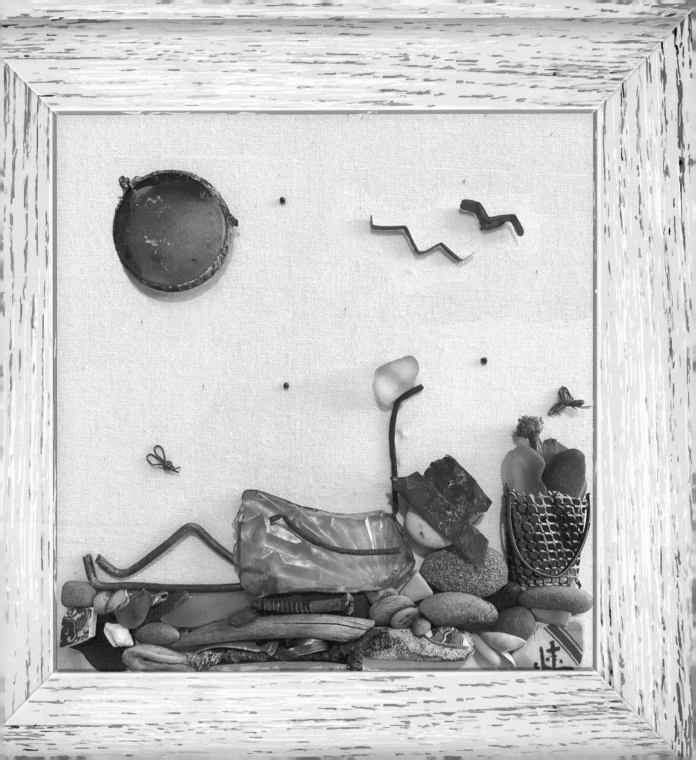

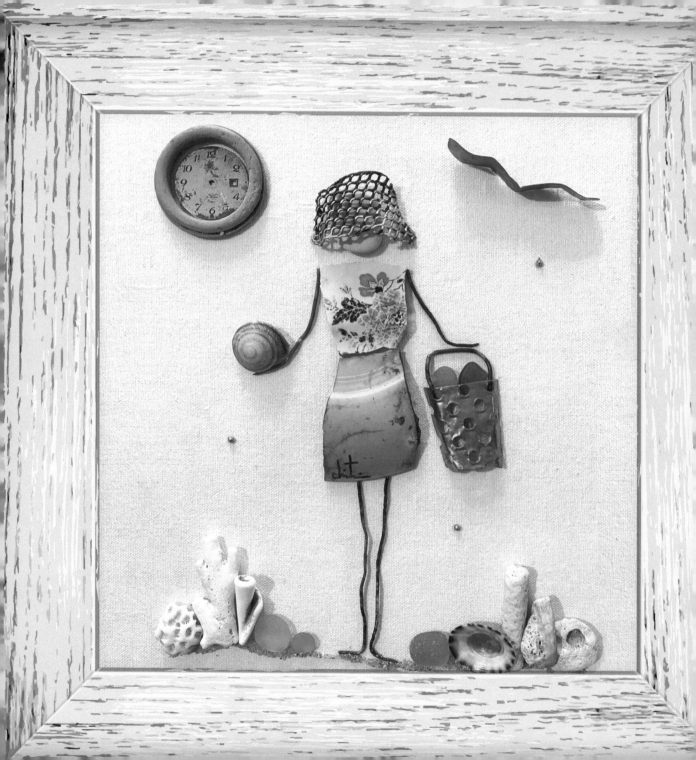

A round corroded powder case?
A coral stem that looks like lace?

The skeletons of sand dollars?
The bones of chitons, urchins, stars?

A sea snail's pretty winding home?
A purple insulator dome?

Some feathers from a shorebird's wing?
A pretty little unknown thing?

25

I pick them up

with gratitude —

my spirit lifts,

refreshed, renewed.

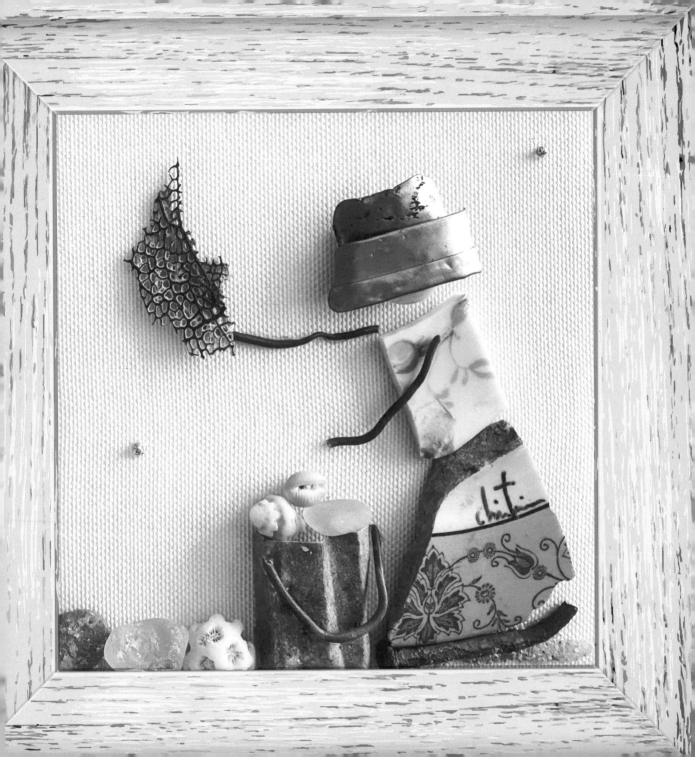

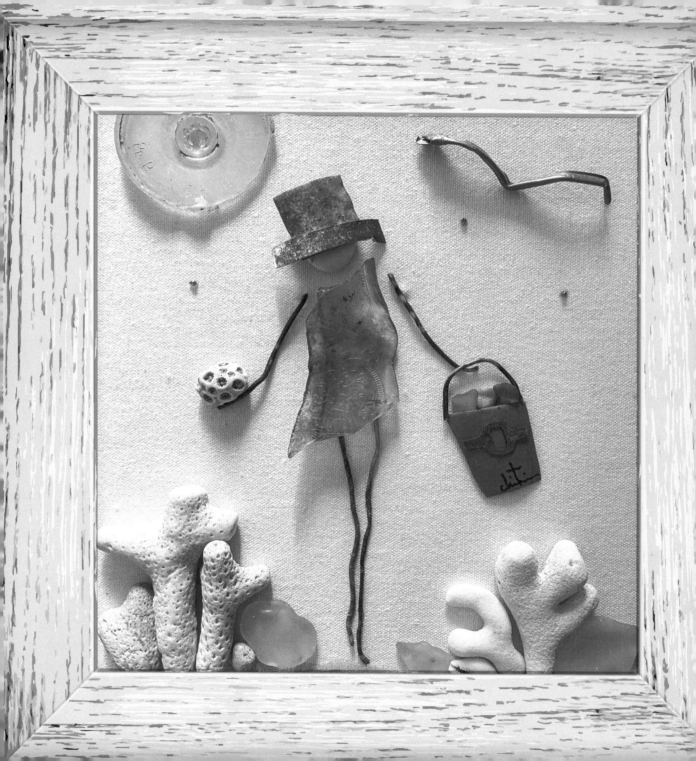

The here and now

pleasantly fills

me with such

overwhelming thrills.

I dance along

the waterline,

and feel true happiness

is mine.

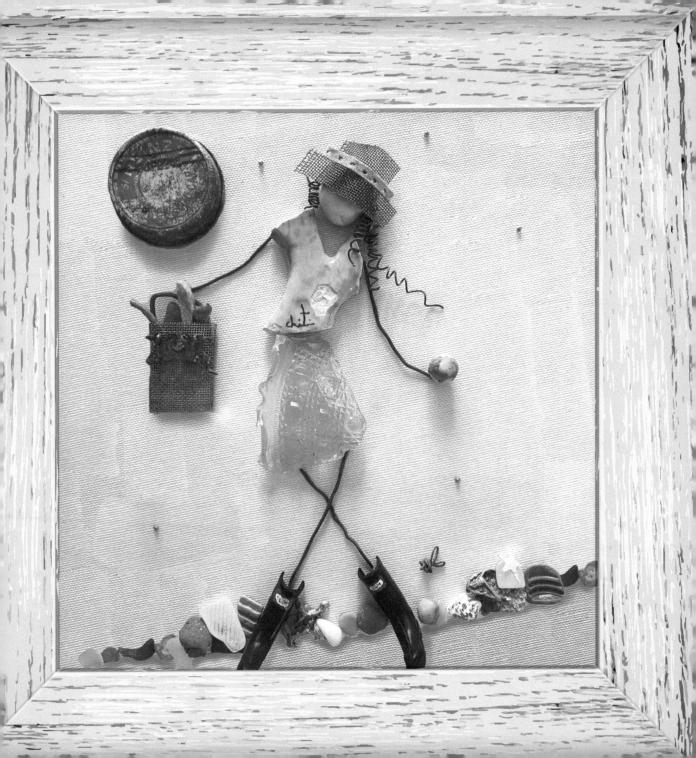

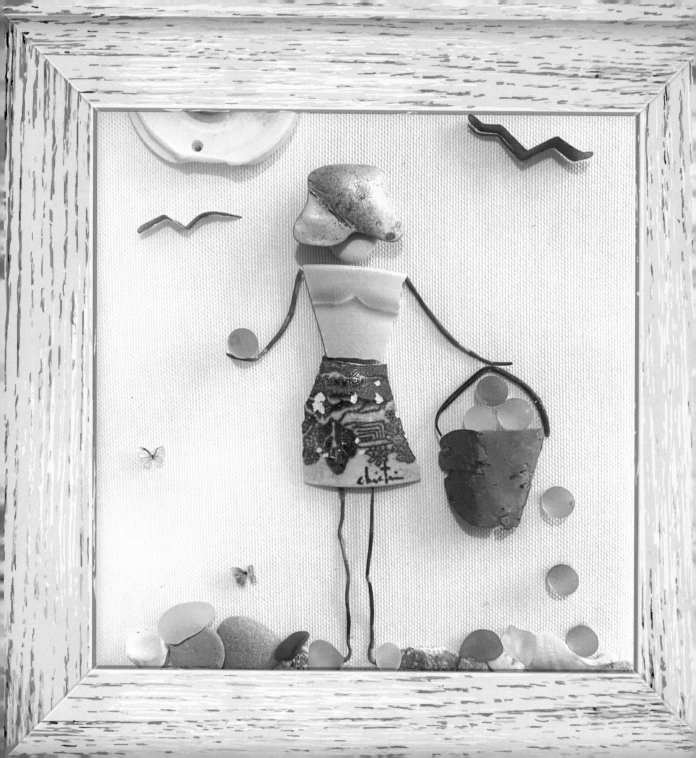

I'm sure that you

have felt like this,

have tasted of

the coastal bliss,

of sunlit moments

at the beach

when perfect peace

seems within reach.

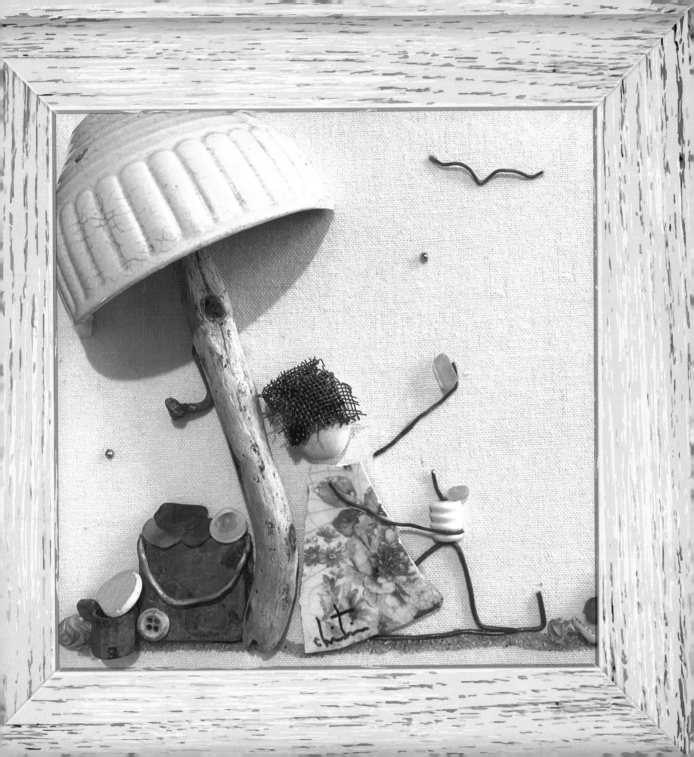

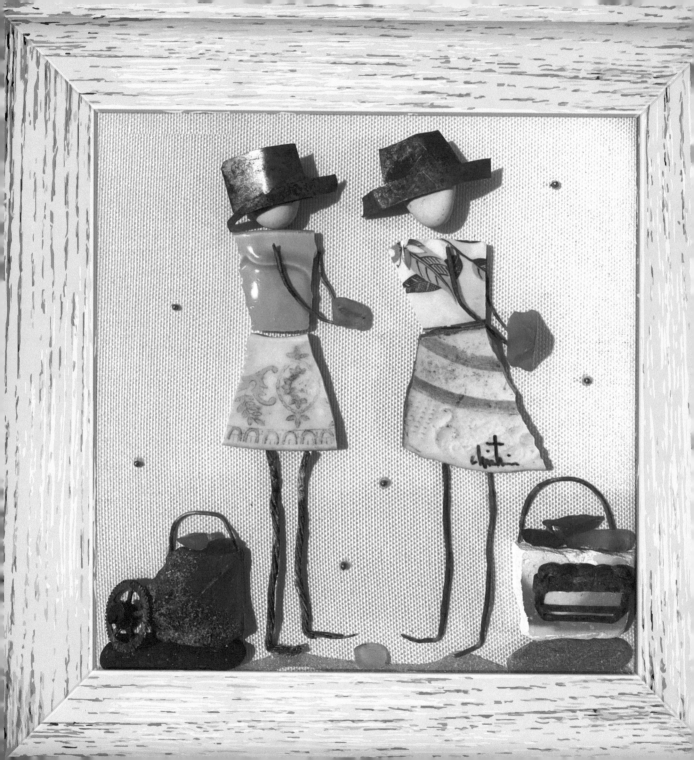

So, should we meet

each other here,

we'll share the things

that we hold dear,

and know we both

need little more

than to be girls

who comb the shore.

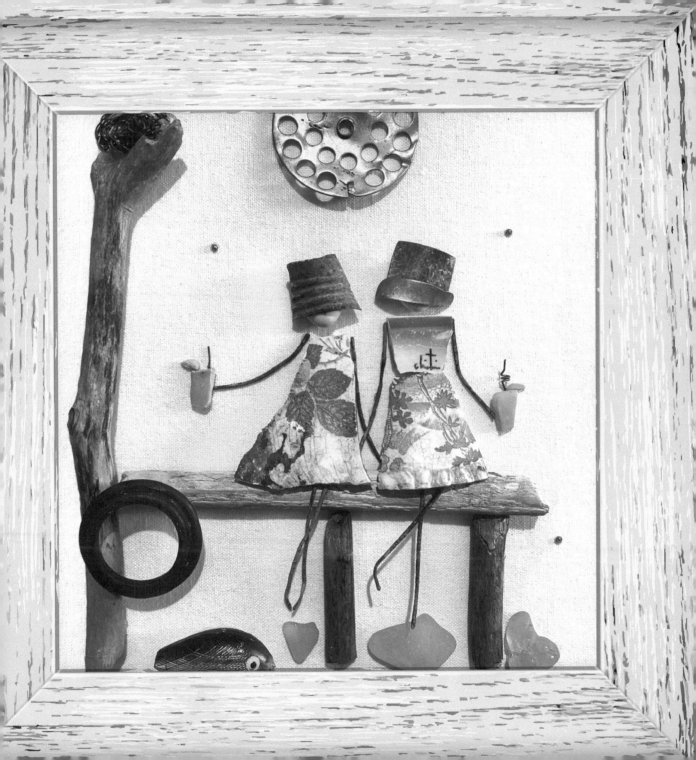

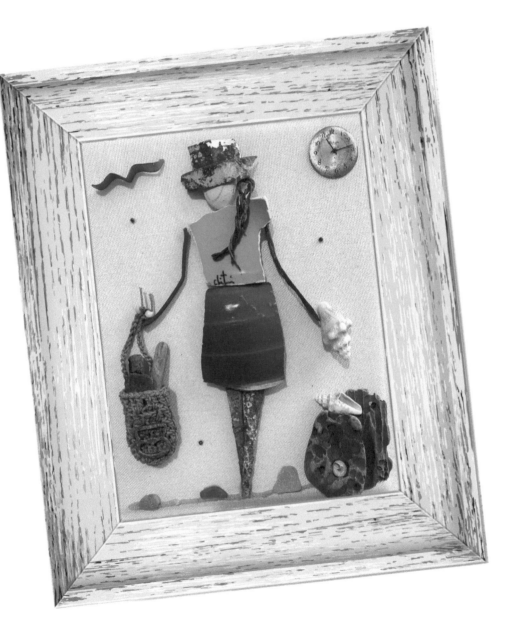

CHRISTINA GRAY

is an assemblage artist who finds beauty in the broken. She draws inspiration from her faith, transforming what was trashed, torn, and discarded into amazing works of art. Her materials are mermaids' tears, surf-tumbled pottery, scraps of metal, and other old sea debris, together with shells, driftwood, and pebbles, found on her frequent beachcombing and mudlarking trips; she loves to hunt for the next exciting treasure that will tickle her imagination. The collages she creates are playful, often whimsical, and always utterly charming.

Christina lives in a small town in rural Georgia with a spectacular natural vantage point, from which, as myth has it, you can see seven states. She loves to spend time with her children and grandchildren, is a passionate cook, and enjoys the company of her pet chicken, Sybil.

Find out more about Christina and her art at

instagram.com/bornagainbits

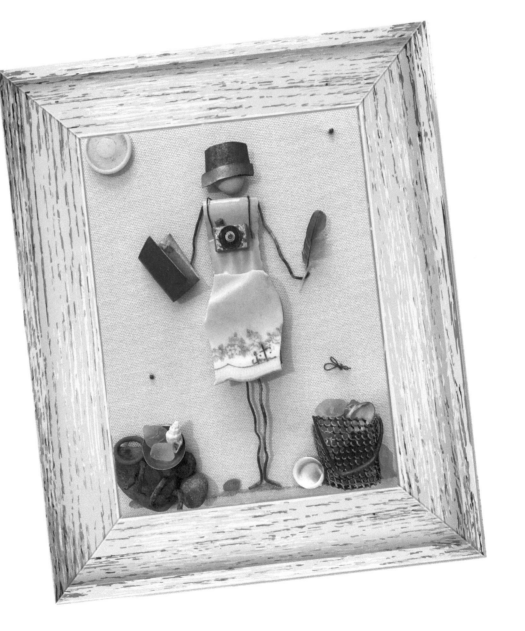

SILKE STEIN

is the author of the women's fiction novel *Foam on the Crest of Waves*, a captivating blend of mystery, romance, and mermaid yarn, set at one of the world's most famous glass beaches. She has also written two middle-grade books, and a volume of poetry titled *My Heart Sings to the Sea*, perfect for all who find joy, solace, and inspiration at the shore. Having been an avid reader since childhood, Silke took the detour of becoming a graphic designer before she discovered her passion for writing.

Silke lives at the south tip of beautiful Vancouver Island with her husband and her ever-growing sea glass collection. Long morning walks at the coast supply her with time for prayer, surf-tumbled gems and shells, photos of the pretty things she can't take home, and ideas for her next writing projects.

Find out more about Silke and her books at

silkestein.jimdo.com

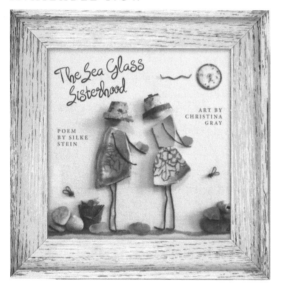

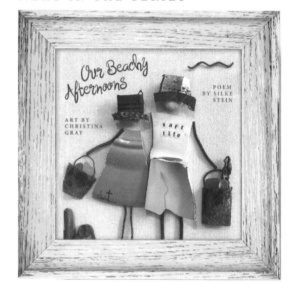

Author's Note

Dear Reader,

I hope you will enjoy *Girls Who Comb the Shore* as much as our previous book. Feedback for *The Sea Glass Sisterhood* has been wonderful. Thanks, everyone, for the encouragement!

I am grateful to Christina for contributing her amazing works of art, and to Maria without whose assistance, skill, and kindness this book would not have been possible.

Please support us by recommending our books to others, giving them a rating or review, and stay in touch by subscribing to our newsletter and following us on Instagram and Facebook.

And don't forget to check out our website for information and upcoming releases:

beachurchinbooks.com

Thank you very much,

and happy beachcombing!

Silke Stein

Published by

BEACH URCHIN BOOKS

Text Copyright: Silke Stein, 2023

Picture Copyright: Christina Gray, 2023

Book design, typesetting, and production:

Silke Stein / Maria Ayala

Printed in the USA
CPSIA information can be obtained
at www.ICGtesting.com
LVHW071033131023
760813LV00021B/1108